PROPERTY OF

Harry Potter

WIZARDING WORLD and all related trademarks, characters, names and indicia are © & ™ Warner Bros. Entertainment Inc.
Publishing Rights © JKR. (s20)

INSIGHTS

an imprint of

INSIGHT SEDITIONS

www.insighteditions.com

MANUFACTURED IN CHINA 10 9 8 7 6 5 4 3 2 1